THE
METROPOLITAN CATHEDRAL
Mdina

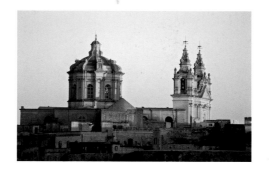

ALOYSIUS DEGUARA

PHOTOGRAPHY
DANIEL CILIA

HERITAGE BOOKS

WITH THE COLLABORATION OF
THE CHAPTER OF THE MDINA CATHEDRAL

2008

HOW TO GET TO THE MDINA CATHEDRAL

By *public transport:*
Bus nos. 89, 81, and 84 from Valletta and alight at Saqqajja bus stop; 86 from Bugibba stops at Rabat Bus Terminus; 65 from Sliema stops at Rabat Bus Terminus.

By *car:*
Main roads leading to Rabat-Mdina follow signs to Mdina. On entering Mdina Main Gate, continue through Villegagnion Street until you arrive to St Paul's Square. Tickets are available from the Catheral Museum, across the visitors' entrance in Archbishop Square.

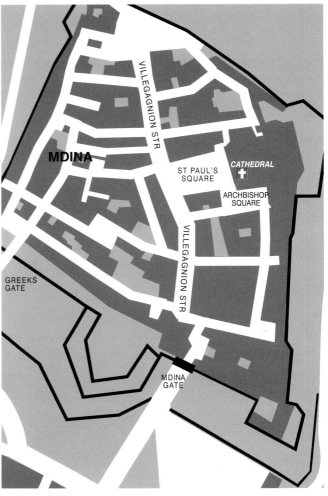

Insight Heritage Guides Series No: 18
General Editor: Louis J. Scerri

Published by Heritage Books, a subsidiary of Midsea Books Ltd, Carmelites Street, Sta Venera SVR1724, Malta
sales@midseabooks.com

Mgr Aloysius Deguara is a member of the Metropolitan Cathedral Chapter and author of various books and papers.

Produced by Mizzi Design & Graphic Services
Printed by Gutenberg Press

Insight Heritage Guides is a series of books intended to give an insight into aspects and sites of Malta's rich heritage, culture, and traditions.

First published 2008

ISBN: 978-99932-7-172-7

INTRODUCTION

Arriving at the grand *piazza* in the heart of the old city of Mdina, one is struck by the towering mass of a building of sombre gravity and awe-inspiring monumentality: the cathedral. It creates a dominating impact on the setting of Mdina as it is complimented by two adjacent baroque palaces, the episcopal residence and the old seminary, the latter hosting the Cathedral Museum.

The cathedral church is the mother church of all the churches of Malta. It is the seat of the archbishop of the whole diocese, from where he teaches, governs, and unites all the Catholics on the island. This cathedral bears the title of 'Metropolitan' since the bishop of Malta was raised to the dignity of metropolitan archbishop and head of the ecclesiastical province of Malta and Gozo in 1944.

Since Norman times, the cathedral has been the see of the bishop of Malta, although the bishops themselves did not always reside in Malta. The succession, since the coming of the knights of the Order of St John in 1530, has been regular. Baldassare Cagliares (1615-33) was the only Maltese native to become the bishop of Malta during the knights' stay, but all bishops after 1807 have been Maltese. Since the beginning of the nineteenth century and following the French occupation, the cathedral chapter started to fulfil its duties both in the cathedral in Mdina and in the co-cathedral of St John's in Valletta, the former conventual church of the Order of St John.

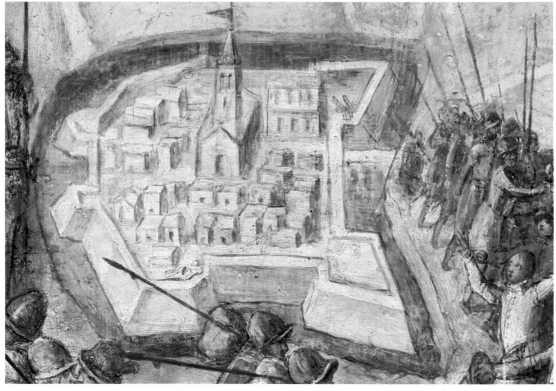

Mdina in 1565, detail from Perez d'Aleccio fresco, Grand Master's Palace, Valletta

THE EXTERIOR OF THE CATHEDRAL

Looking at the huge building of the cathedral church, built by a leading Maltese architect Lorenzo Gafà (1639-1702), one is struck by its bold rhythmically articulated façade. Its ponderous gravity has few decorative details and its academic austerity is handled with ease, creating a well-ordered highly harmonious balance. It is set on a low parvis approached by a short flight of three steps.

Both Corinthian below and Composite orders above are used to create a robust appearance. The pilasters are left plain and there are vast areas of blank masonry. The central bay comes forward to give the façade a degree of three-dimensional recession necessary to break the monotony of a flat surface. This is crowned by a triangular

pediment holding the two-armed cross. High above dominates the spectacular dome, the richest in Malta, a landmark visible from the greatest part of the island. A scrollwork provides a fitting crown to the square-headed door and its profile is balanced by three shields, sculpted by Giuseppe Darmanin, a leading marble sculptor. These are respectively the arms of the municipality of the city of Mdina, of Bishop David Cocco Palmieri (1684-1711), and of Grand Master Ramon Perellos (1697-1720). The chestnut door was designed by Gio Battista Caloriti from the *bottega* of Mattia Preti. The elegant statues of St Peter and St Paul were modelled by Giuseppe Stefanin – they reveal an artist of notable accomplishment – and cast by Luca Menville of the famous Menville family. The round-headed window in the upper storey gives a fitting sense of climax to the central piece. The coloured coat of arms of the present archbishop acts as a focal point of the whole façade.

The elaborate belfries used to contain six bells, the oldest of which was cast in Venice in 1370 by Magister Victor et Nicolaus Frater, presently preserved in the Museum. The bells were hoisted to their place by a hazardous operation in 1699. The gang of six slaves who carried out this task won the admiration of the chapter and were given a gift of 11 *scudi*. The two clocks, which show the hour and the calendar respectively, were manufactured by the well-known Maltese clock-maker Michelangelo Sapiano in 1888. One of the clock-bells dates back to 1499 and the other two date to 1616 and 1633 respectively.

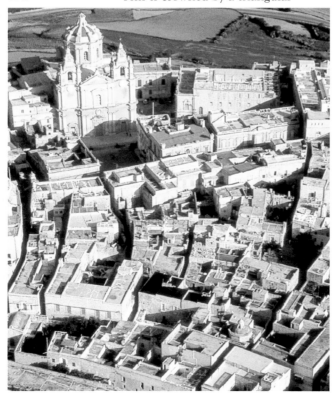

Aerial view of central Mdina with the cathedral and the square in front of it

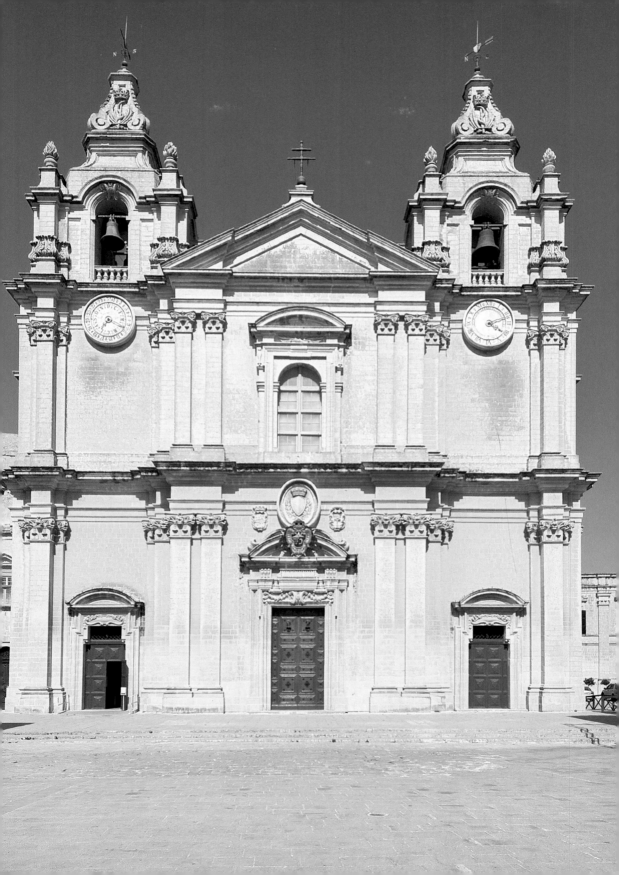

THE NEW CATHEDRAL

The first idea to build this cathedral church dates to 1679 when the chapter, encouraged by Bishop Michael Hieronymus Molina (1678-82), decided to replace the choir of the 12th-century Norman cathedral by a modern substitute in the new baroque style. They appointed Lorenzo Gafà to design and oversee its construction. The first stone was laid during the same year as the chapter's decision in 1679. The new building was attached to the old apse, holding it from collapsing, but it must have overwhelmed the old building making it look poorly modest and old-fashioned. The choir is indeed remarkable for its dynamic design. The giant composite pilasters carry a boldly defined tablature that serves to draw one's attention to the elegant altar in the centre of the niche, which is the focal point of the church, holding the altarpiece and two other paintings showing the martyrdoms of St Peter and St Paul and another two showing the miracles of St Paul by Mattia Preti (1613-99) on the sides of the choir.

Three years after the completion of this artistic work, on Sunday 11 January 1693, an earthquake, the result of volcanic activity of Mount Etna, hit Malta. The old cathedral, with the exception of the newly built choir, and a good number of the houses of the city were heavily damaged; other buildings at Rabat and even in Birgu and Cospicua, including the Inquisitors' Palace and the convent of St Theresa, were considerably damaged. No deaths were registered.

This event served to encourage the hidden resolve of the chapter to replace the old cathedral by a more noble edifice. Still a prolonged discussion took long to decide in favour of a entirely new cathedral and to join the new project to Gafà's choir. The earthquake of 1693 helped the chapter to arrive to the final conclusion. More obstacles had, however, to be overcome.

The left side of the main aisle

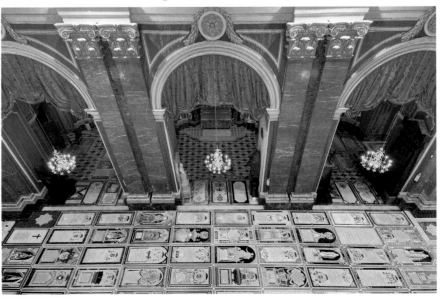

Soon after the earthquake, Mederico Blondel, the resident chief engineer of the Orde, along with his commission, reported to Grand Master Adrien de Wignacourt on the state of Mdina. Blondel blamed the damage of the earthquake more on the state of old age and neglect of many of the buildings than on the intensity of the shock.

However, on 11 April 1693 the chapter prevailed on the report prepared by military engineer Mederico Blondel (1628-98), and the *capi mastri* Giovanni Barbara and Vincenzo Casanova, and decided to submit, in collaboration with Lorenzo Gafà, a separate report on the state of the cathedral. The commission agreed that only a part of the church had collapsed, but the structure was weak on account of its old age. A new building was to replace the old structure.

The chapter unanimously decided to execute its decision and embarked

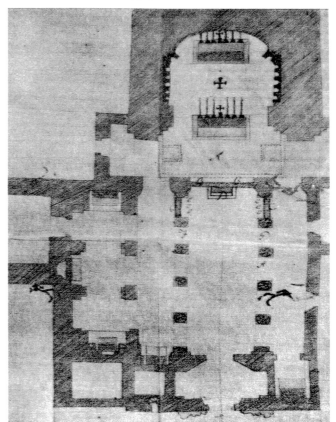

on rebuilding the church on the plan and the wooden model made by Lorenzo Gafà as approved by the Blondel commission. The dismantling of the old cathedral was soon started, together with the preparation of the new foundations

Work was undertaken immediately on the seventeenth-century sacristy which was not heavily damaged. It had to be included in the complex of the new cathedral. The doorway was to be fitted with the west doors of the old cathedral.

The building was completed in 1702, a few months before the death of its inspired designer and famous architect, Lorenzo Gafà, who died on 16 February 1703 at the age of 64. The church was consecrated on 8 October 1703 by Bishop Davide Cocco Palmieri. The work on the dome was completed on 24 October 1705.

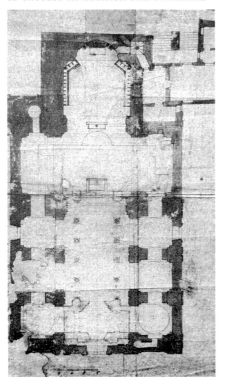

On next page: General view of the main nave floor laid with tomb stones

Architectural plans of the cathedral, pre-1696 in its romanesque shape (top) and post-1696 with its baroque plan (left)

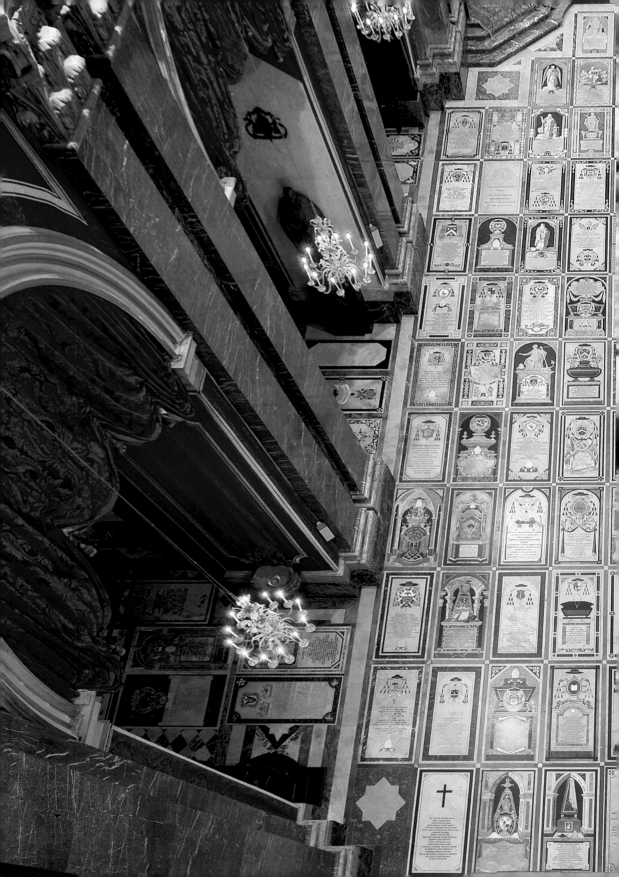

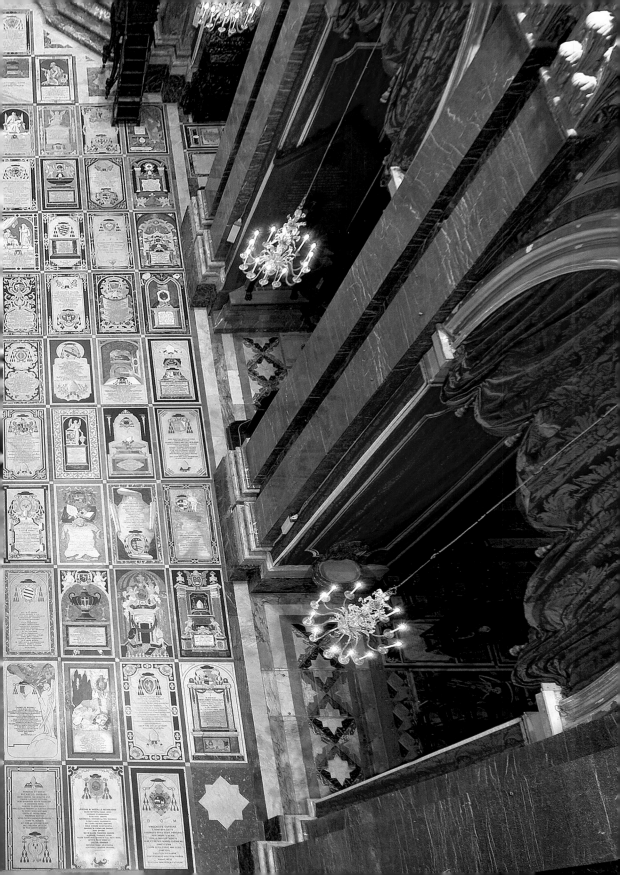

THE MAIN NAVE

On entering the cathedral, one can admire the inlaid marble slabs which cover the floor of the whole nave and many other parts of the aisles; some of these are real tombs; others commemorate the canons of the cathedral and some other laymen, such as the members of two noble families and one of the *Maestro di Cappella*, Francesco Azopardi (1748-1809). Several bishops are interred in the chapel of the Blessed Sacrament and in the transepts; their ledger tomb slabs have rich designs of great artistic value with various inlaid coloured marble. Two slabs are embedded in the wall near the side door leading to Archbishop Square. Some bishops and the remains of five other bishops, who were previously buried in the chancel, are interred in the crypt.

The earliest surviving episcopal memorial in the cathedral commemorates Bishop Tommaso Bosio (1538-39), formerly vice-chancellor of the Order of St John. His tomb was marked with a white marble ledger stone which is now embedded in the wall of the inner vestry close to the entrance of the monumental staircase of the chapter hall. Another episcopal ledger stone, albeit in a ruinous state, is that of Bishop Baldassare Cagliares, a prelate of Maltese nationality and *uditore* to Grand Master Alof de Wignacourt who was another benefactor of the cathedral. Five

The main aisle

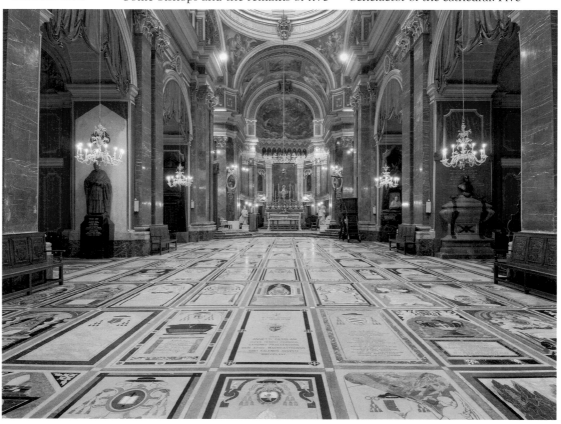

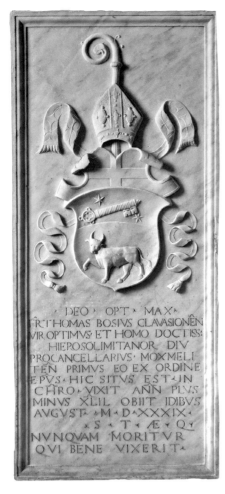

The tombstones of Bishop Tommaso Bosio (1535-39) in the Sacristy (left); of Bishop Labini (1780-1807) in the middle of the left transept (right); and Bishop Cagliares (1614-33) in the crypt below the church (below)

fragments have been pieced together and cemented into the wall in the vestry.

The ledger tombstones of the bishops lie in the transepts: two of them were designed by Francesco Zahra (1710-73). Some of the other tombstones in the main nave were designed by Giuseppe Hyzler (1793-1858) and his colleagues: these insisted on producing artistically designed religious symbols. Though the lapidary in the cathedral differs from that of St John's in Valletta, it is still greatly admired for its artistic value. Chronologically the former

On the next page: The vault of the nave depicting scenes from the life of St Paul by Vincenzo, Antonio, and Francesco Manno

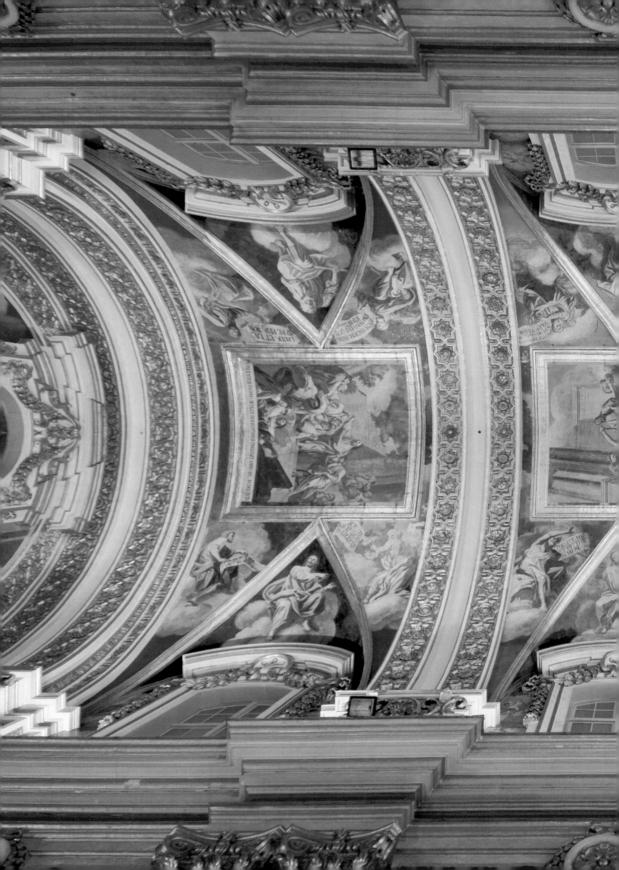

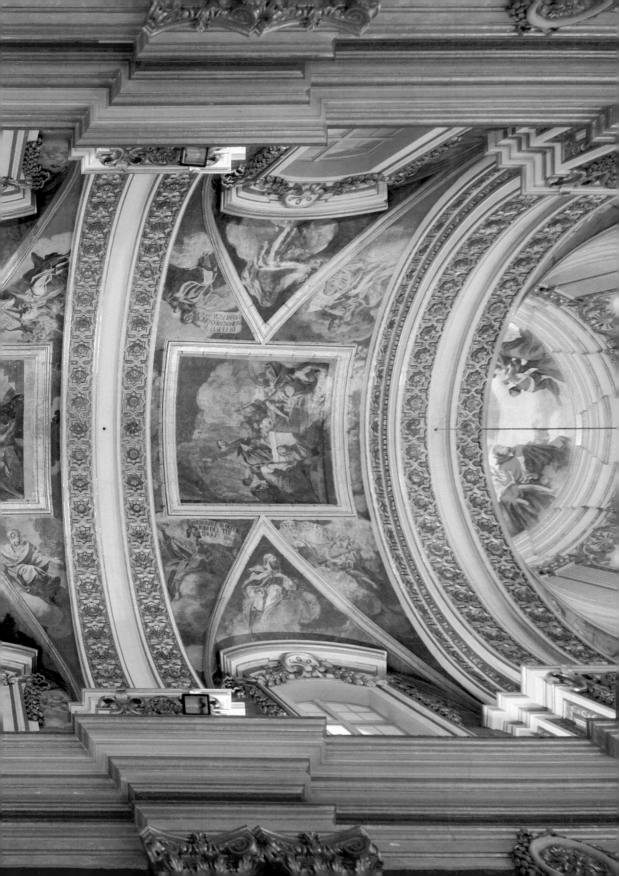

continues an interesting chain of development.

The ceiling of the cathedral represents scenes from the life of St Paul which were painted in fresco by the brothers Vincenzo, Antonio, and Francesco Manno from Sicily. The work was completed in 1774 as confirmed by the inscription above the main door. They also painted the dome. Unfortunately the whole fresco of the dome was destroyed during another earthquake in 1856. The dome itself was initially saved from being demolished through the intervention of master-mason Bonavia who was then in charge of the reconstruction works. The fresco was replaced by another Italian artist, Giuseppe Gallucci, in 1860. It later suffered the same fate: small fragments of this last fresco can be seen in the

The dome, painting by Caffaro Rorè depicting *The Glory of St Peter and St Paul*

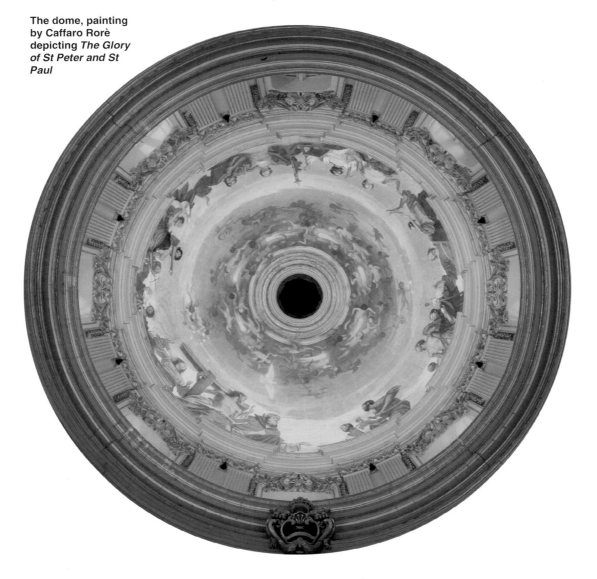

dressed as a Soldier, by *Hananias*; *The Immaculate Conception of Our Lady*, and *St Joseph*. They were produced in Toulouse in the workshop of Victor Gesta. The most important one, that above the main door, was inaugurated in December 1877. Another similar stained glass window in the chapter hall represents the *Descent of the Holy Spirit on the Blessed Virgin and the Apostles*.

Just on the left of the main door stands the baptismal font, a survivor of the old cathedral; it is believed to have been the gift of Bishop Giacomo Valguarnera in 1495. The scalloped basin is sustained by four caryatid-angels clustered together on a circular base. In this remarkable work, late Gothic elements are handled in a way that betrays an obvious familiarity with early Renaissance principles. The partially polished marble of the basin gives way to the slender linear beauty and grace of the load-bearing angels who strain under its weight. Their raised arms and bent knees under the undulating drapery and the gently flowing locks of their hair create a pleasing rotational symmetry eloquent in its restrained sense of movement. On the basin there are two armorial shields: one is emblazoned with the arms of the town council, the other is left blank with the episcopal mitre only. (It

Museum. The dome painting was restored by Giuseppe Calì but in 1927 it was totally obliterated owing to urgent construction works. The interior of the dome, painted in the twentieth-century by Mario Caffaro Rorè of Turin, represents *The Glory of St Peter and St Paul*. The ceiling was restored by Samuel Bugeja in 1956.

The large coat of arms sculptured on the main arch, facing the high altar, is emblazoned with the arms of Clement XI, the pope who reigned during the building of the new cathedral. Just below the dome, there are four paintings in fresco representing the Evangelists made by Vincenzo Manno in 1794.

The ceiling is adorned and lit up by three stained glass windows representing *The Baptism of St Paul*,

**On next pages:
Stained glass
depicting the
miraculous
healing of the
Roman centurion
by St Peter; 15th-
century baptismal
font; and, statue
of St Publius by
Giuseppe Valenti**

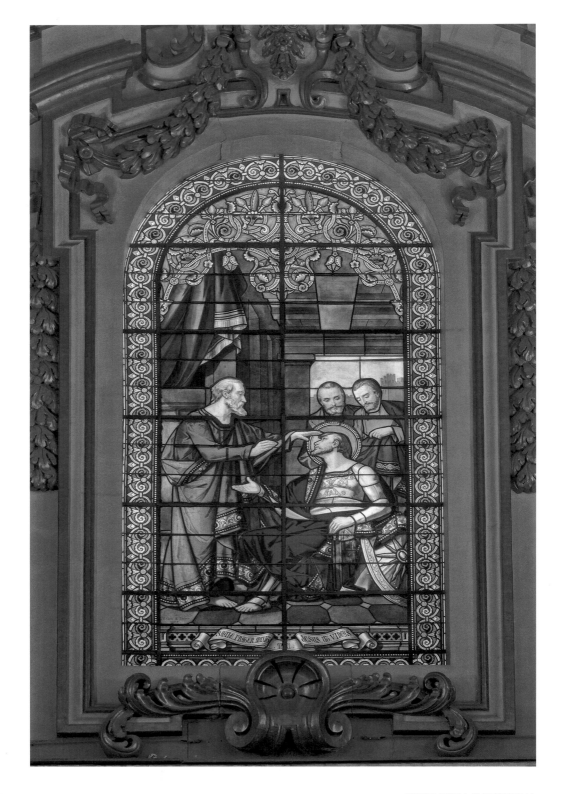

was probably finished during a *sede vacante* after Valguarnera.) The two medallions show the hieratical figures of St Paul and the Baptism of Christ respectively.

An octagonal pyramidal hood crowned by a wooden statue of St Paul is placed on the basin; the richness of its carved decoration reveals an accomplished artist's hand. The *Baptism of Christ* and the *Beheading of St Paul* are artistically represented; other faces and puttini with a drapery decoration fill the faces of the pyramid.

On the other side of the main door, there is a beautiful statue of St Publius, traditionally held as the first bishop of Malta elected by St Paul himself. Made by Giuseppe Valenti of Palermo in 1885, it shows the saint enthroned in pontifical robes. The saint's blessing gesture shows the artist's academic training.

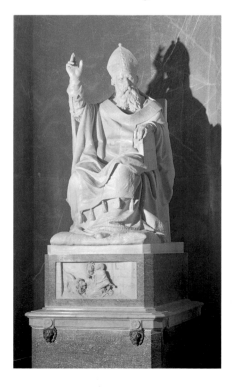

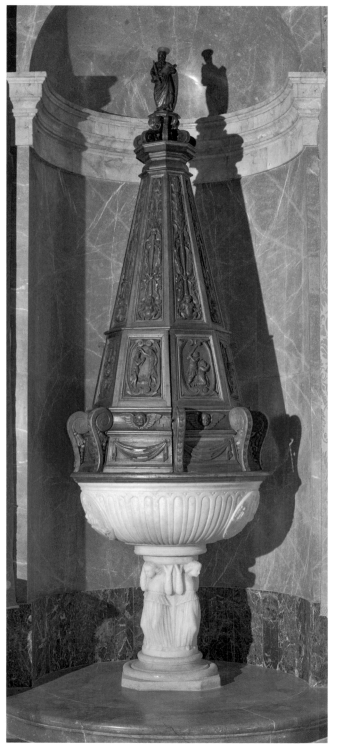

THE NORTH AISLE

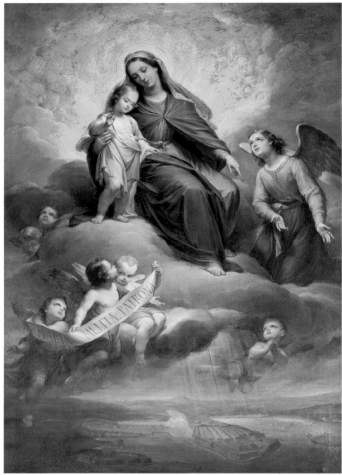

Pietro Gagliardi,
*Maria Melitae
Patrona*

**Opposite:
The altarpiece of
*The Descent of
the Holy Spirit* by
Francesco Grandi**

**The monument of
Archbishop Gonzi
by Vincent Apap**

of Valletta and the two harbours spread across the base of the painting. Gagliardi also painted the two lunettes representing the *Assumption in Heaven* and the *Crowning of the Blessed Virgin*. The dignified and subdued Baroque altar is flanked by the coats of arms of the ancient Maltese Castelletti family. The white marble monument commemorating Bishop Publio Sant, standing in this chapel, was sculpted in Rome by Mario Gori in 1874. Standing opposite to it is the bronze monument of Archbishop Michael Gonzi (1944-76), the first metropolitan archbishop of Malta. It was modelled by the Maltese artist Vincent Apap in 1971.

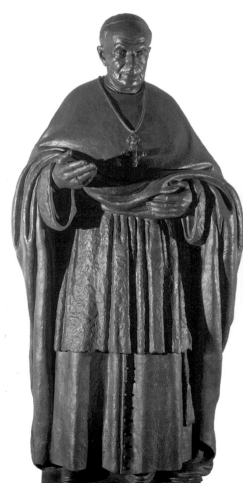

The Altar piece over the first altar to the left is a nineteenth-century depiction of *The Descent of the Holy Spirit on the Blessed Virgin and the Apostles* which replaced the original altarpiece, now in the sacristy. Like its two adjacent lunettes, it was painted by Francesco Grandi (1831-91), a most technically competent Italian artist. It is an attempt to fit in with the Baroque milieu of the cathedral.

The second altarpiece, by Pietro Gagliardi (1809-90), shows *Maria Melitae Patrona* as she protects the island symbolized by the scene

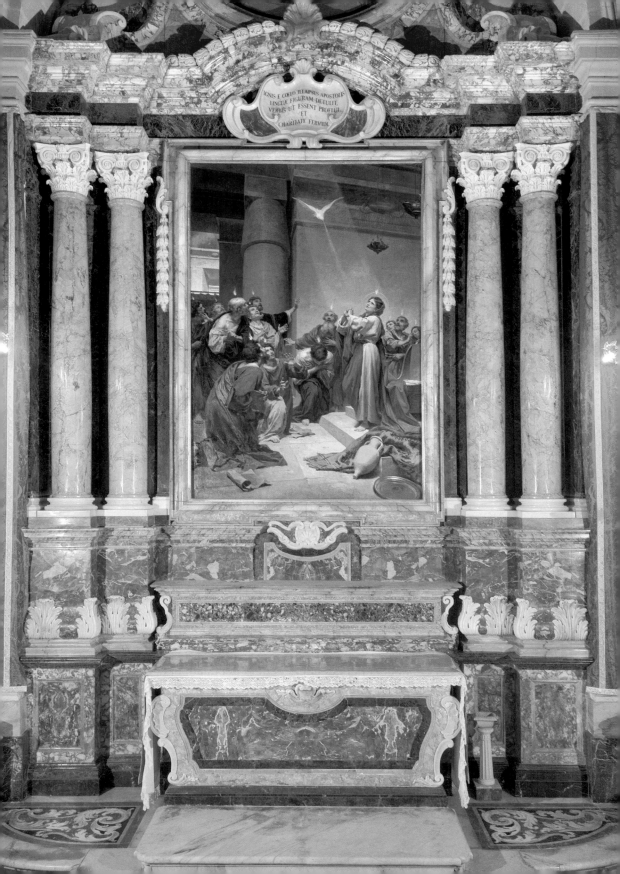

IGNIS E COELO ILLAPSUS APOSTOLIS
LINGUAE FIGURAM DETULIT,
VERBIS UT ESSENT PROFLIT,
ET
CHARITATE FERVIDI

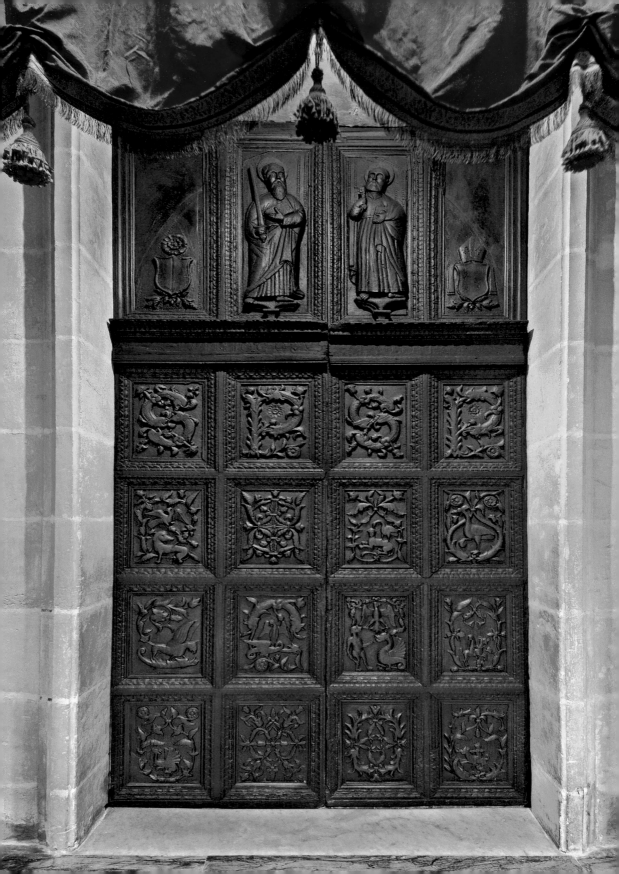

The chestnut timber door in the next aisle was saved from the ruins of the old cathedral after the earthquake of 1693 and was adapted to fit the entrance of the old sacristy in the new building. The door carries the date of its production in 1530 and was made by Cola Curmi who was sent to Sicily to select the wood for it. In Sicily, Curmi might have taken the opportunity to inspect other cathedral doors for his inspiration. The arched top of the door, arranged to fit its new place and dimensions, shows the Gothic style of the original door. The iron hinges and probably also the other metal works were made by Pietro Blondel.

The door, a splendid example of early sixteenth-century wood carving in the Sicilian tradition, is of a remarkable interest. Its abundant decoration reaches a climax in the two hieratical statues of St Peter and St Paul; it comprises the armorial shields of the municipality of Mdina and of the diocese, *sede vacante*; the numerous carvings in the panels with reliefs of allegorical birds, animals, and plants are archaic and suggest the influence of an important prototype, possibly Sicilian.

Opposite: Original door of the old cathedral, now at the entrance of the sacristy

The same door set in the model of the old cathedral

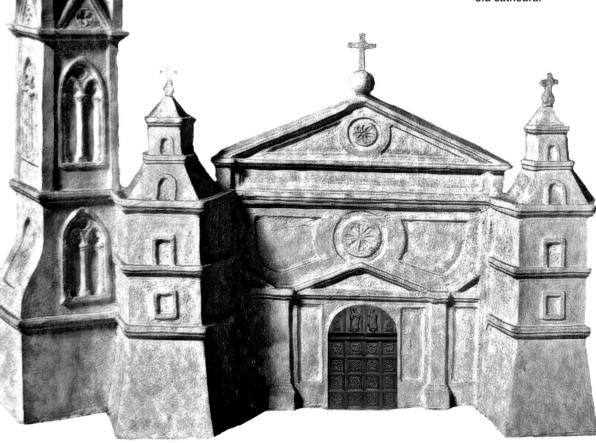

THE SACRISTY

The sacristy, behind this door, is a nobly proportioned hall with a ribbed and coffered barrel vault. A boldly projecting moulded cornice marks the division between walls and ceiling. The treasurer of the cathedral could keep a watchful eye on the treasure, kept in this room, from a window intended as a spyhole. Large ornate cupboards, stained and veneered to evoke the sensation of the natural state of the timber, cover the four walls; they are the finest example of seventeenth-century cabinet-making in Malta. A frieze of triglyphs and dentils forms a crowning cornice carrying gilt shields with the effigy of St Paul alternating with the episcopal arms of Bishop Baldassare Cagliares of whose munificence the whole was built. The focal point of the hall is the altar piece which carries a richly ornate wood sculpture. The painting

Top: *Count Roger*
Above: *Santa Caterina*
Opposite: Coffered
barrel vaults
Below: General view
of the sacristy

representing the *Deposition from the Cross and Our Lady of Sorrows*, emblazoned with the arms of Bishop Cagliares, is the work of Bartolomeo Garagona (1627).

Two other canvases, representing *Pentecost* and *The Guardian Angel* respectively, are both from the *bottega* of Mattia Preti. Originally sited in the church, they were replaced by altarpieces by Francesco Grandi and Pietro Gagliardi. Other paintings in the sacristy include the beautiful work of Alessio Erardi (c.1671-1727) representing *The Victorious Count Roger granting Freedom to the Christian Slaves*, a good copy of Caravaggio's *Deposition from the Cross*, *Santa Caterina* by Preti's *bottega*, the *Assumption of Our Lady* by an unknown Maltese artist which was probably in the old small church of Donna Manna, and a few other smaller canvases.

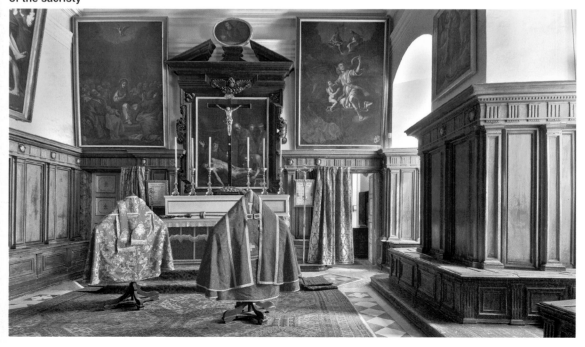

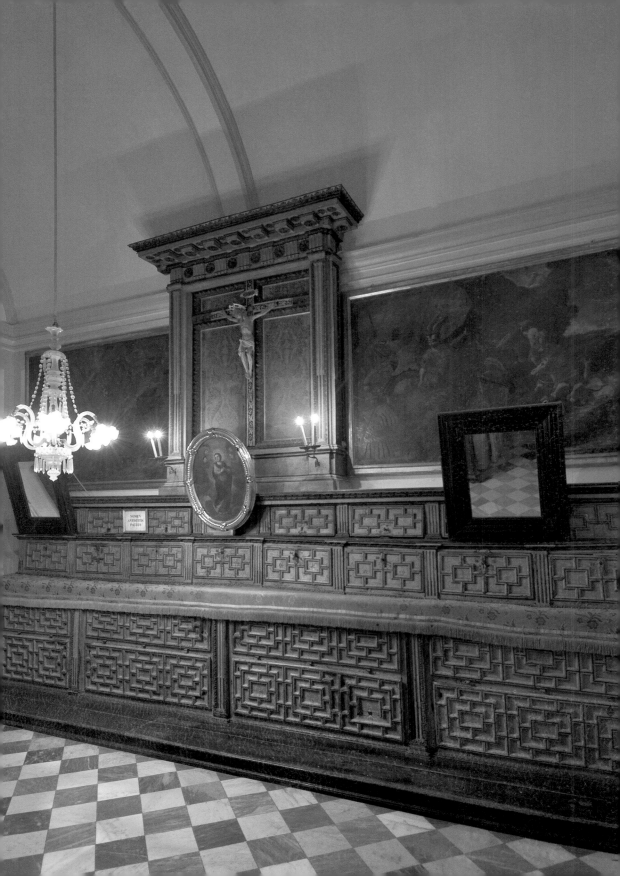

THE NORTH TRANSEPT

The chapel in the left transept is dedicated to the Annunciation The large splendid and striking altarpiece, produced in 1886 by Domenico Bruschi (1840-1910) of Perugia, dominates its immediate Baroque atmosphere; it replaced an old painting of the *Annunciation* by Preti's *bottega*, now in the Museum. The dark-faced figure of the Virgin Mary commands respect and compensates for the starry blue vestment of the angel.

On the right-hand side of the transept is the seventh canvas of Mattia Preti and his *bottega*, *St Paul conquering the Moors*. It represents the popular Maltese legend of how St Paul, during a North African corsair raid on Mdina in 1429, appeared on the bastions of Mdina riding a white steed to scatter away the infidels. It has flashes of good drawing and chromatically crisp passages. The lower register, which illustrates the rout of the infidels, suggests a limited participation by Preti himself.

Opposite this painting is the old organ of the new cathedral commissioned in 1774 to Antonio Rossi of Naples. It was restored to its original state by Robert Buhagiar in 2005.

The decorations of the chapel of the Blessed Sacrament are of great interest. The dome, the lunettes, and

Chapel of the Annunciation

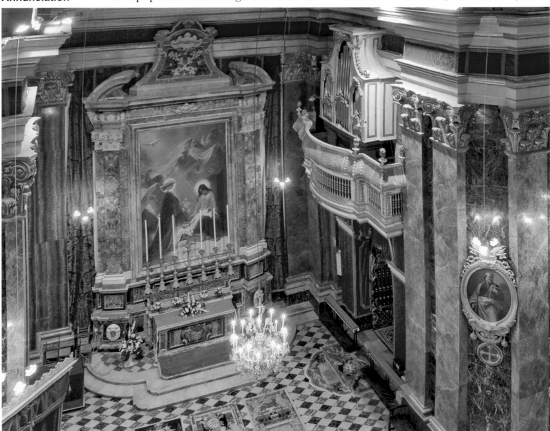

the pendentives are all related to the Holy Eucharist. In the dome there is *Jesus giving the Holy Communion to St Peter, Christ together with the Disciples of Emmaus,* and *St Paul adoring the Blessed Sacrament.* The lunettes are dedicated to the Blessed Virgin, her Maternity, her Presentation in the Temple, her Visit to Elizabeth, and her Assumption. All were produced by Vincenzo Francesco Zahra (1710-63), Malta's foremost baroque artist.

Francesco Zahra also prepared a richly ornate reredos for the chapel with the exuberantly rich frame of the miraculous icon of the *Madonna of St Luke* as its focal point of interest. Worth noting are the curvaceous festoons and foliated garlands with luxurious scroll motifs, the cartouches, and the simulated drapery hangings. The visual impact is enriched by the use of bronze ornamentations in both the altar and the reredos.

Archbishop Paolo Alpheran, paid for the execution of all the marble works; in 1740, he also donated the silver candlesticks, the *Carte Gloria*, and the *paliotto* produced in Rome by the silversmith Belli.

The icon of the *Madonna and Child*, is ascribed by popular tradition to St Luke who was shipwrecked with St Paul on the shores of Malta and stayed three months with him. The earliest mention of this tradition lies in the records of the pastoral visitation of 1615, which refers to it as 'a very ancient tradition of the inhabitants'. It may have belonged to the early years of the thirteenth century. Solemnly crowned in 1897, it has been always venerated with great devotion in the cathedral and all over Malta. The silver box enclosing the icon, once protected was by a silver 'risa', was produced in 1911 on the design of Abraham Gatt of Cospicua.

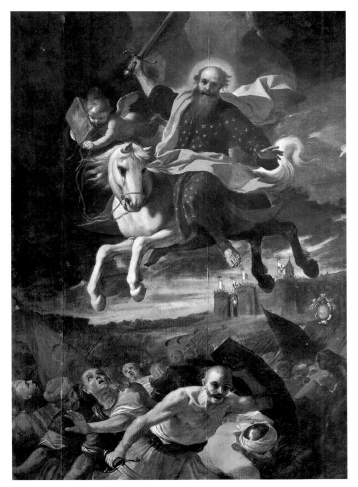

Bottega **of Mattia Preti, *St Paul conquering the Moors***

The magnificent monumental silver tabernacle and monstrance shrine on the altar, also the gift of Archbishop Alpheran, seems likewise to have been designed by Zahra. It consists of an arched door on which there is a gilt applied figure of Christ the Redeemer carrying the cross within a frame of acanthus gilt-leaf applied work on the recto. On the verso there is a very good gilded work of the symbols of the Holy Eucharist surrounding a cross surmounted by an open crown, all in Rococo style. The door is flanked by two scroll-shaped pilasters on each side. The monstrance throne

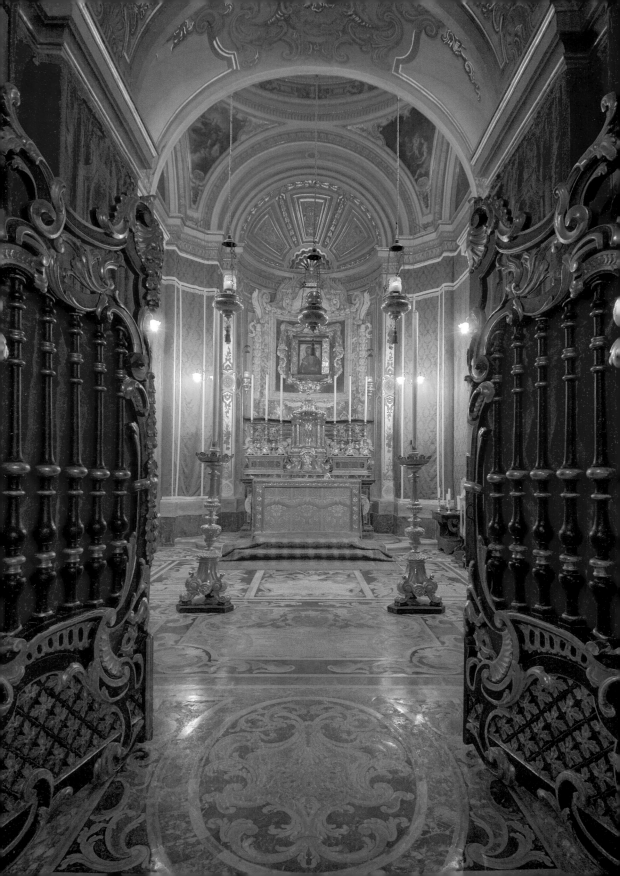

fits exactly on the underlying tabernacle. It consists of a concave niche surrounded by two Corinthian columns in front and two on each side at the back, all entwined by applied cast and gilded vine tree. At the back there are gilded applied ribbon and scroll motifs surmounted by a dove, a figure of the Holy Spirit. An open crown is supported by the underlying columns and forms a canopy to the niche itself. This particular artifact is one of the best creations ever produced by Maltese silversmiths. The assay mark is of eighteenth-century Rome – '*Argento dell'ombrellone*' but on the other parts the maker's mark is that of Annetto Pullicino – 1723.

The altar is made of *giallo antico* marble and two slabs of *lapis lazuli* with silver ornaments. The total sum paid by Archbishop Paolo Alpheran for the chapel amounted to 10,800 *scudi*.

Three bishops, Giacomo Cannaves, Davide Cocco Palmieri, and

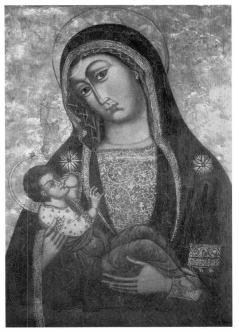

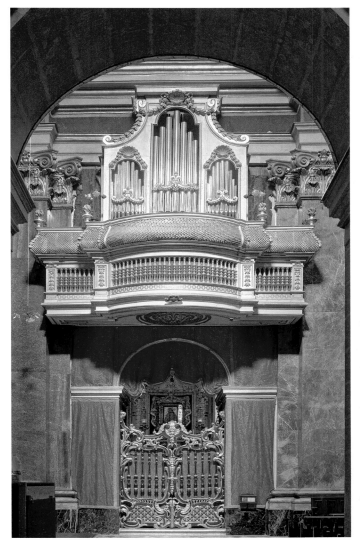

Bartolomeo Rull, are buried in the chapel. Their ledger tomb slabs were designed by Francesco Zahra and manufactured by Claudio Durante with inlaid superbly Baroque marble. On the initiative of the chapter, a memorial to Archbishop Alpheran was produced by the same artists; it matches the best tomb stone in the conventual church of St John's in Valletta. The chapel is enclosed by an elaborately carved and gilt wooden gate, installed in 1757.

The pipe organ built in 1774 by Domenico Antonio Rossi

The altarpiece of the chapel

Opposite: The Chapel of the Blessed Sacrament

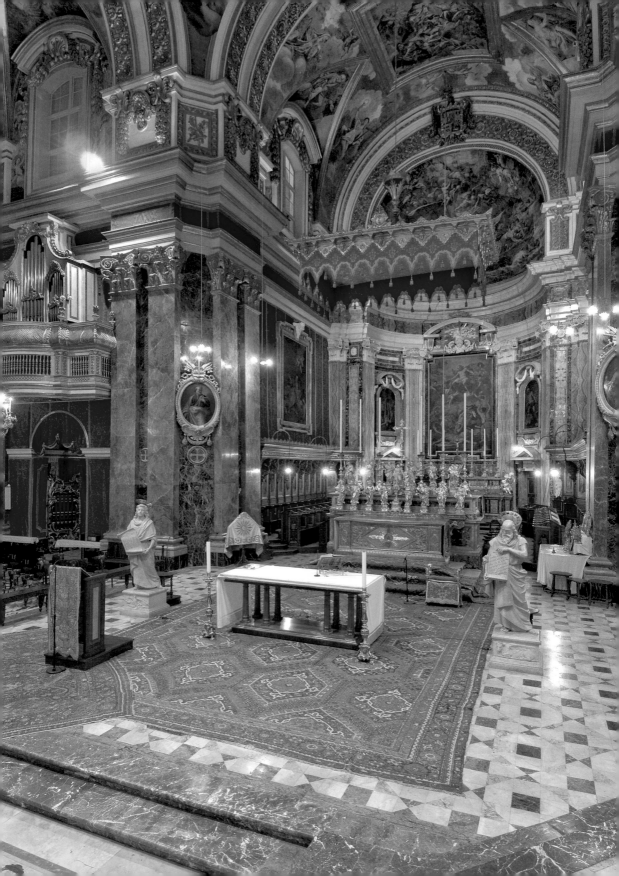

THE CHANCEL

Reaching the high altar from the Gospel side, one should note the marble *mensa*, which has been preserved from the old cathedral. Placed in the old cathedral in 1626, it was consecrated by Bishop Cagliares and dedicated in honour of Almighty God, the Blessed Virgin Mary, and St Paul to whom the cathedral is dedicated. Old relics, consisting of a finger of St Hermes and a tooth of St Recessi, were placed in the altar. When the new cathedral was built, the Cagliares altar was transferred to its proper place. A legend says that the old large marble *mensa* was once the upper part of the tomb of Publius' father. According to the same legend, his grave lies beneath the same high altar.

In 1726, the old wooden ornament at the back of the seventeenth-century marble stone, which had been partly painted as marble and partly gilt, was replaced by a new one made of precious marbles and a long *lapis lazuli* block. This was made in Rome by the Roman *scalpellino* Francesco Arnellini on the measurements of Architect Raimondo Bianchi and the design of Carlo Gimach, a Maltese artist living in Rome. The marble piece was built by a group of Sienese marble-workers who were in Malta working on the Zondadari monument in St John's. The expenses were paid by Canon Francesco Mangion who primarily wanted to execute his mother's will to produce a golden monstrance for the relic of St Paul. After long discussions, the chapter obtained permission from the pope to alter the will and to use the money to pay for the new altar piece. The old wooden ornament was donated to St Paul out of the Walls church in Rabat and was later transferred to St Paul's church in Safi, where it still stands.

The two oval mosaic medallions in the chancel representing the Apostles *St Peter* and *St Paul* were executed by Luigi Moglia in 1873, the subjects being based on paintings by Fra Bartolomeo della Porta (1472-1517), who produced several works of art at the Palazzo del Quirinale. The oval marble frames were designed by Pietro Gagliardi.

The two marble lecterns in front of the high altar represent the Evangelists *St Luke* and *St John*. They are the work of Giuseppe Valenti of Palermo, the same artist who executed the statue of St Publius near the main entrance. The life-size statues have a more classical restraint and nobility.

The chancel floor was paved in marble long after the tombs of five bishops had been removed. The central coat of arms in the floor is that of Bishop Gaetano Pace Forno (1858-74), who paid for the marble.

On the right-hand side of the chancel, fixed to the major pilaster, stands the classical throne, or *cathedra*, of the metropolitan archbishop of Malta being the right and proper presidential place in a cathedral church. It has been transferred to this major pilaster and took the place of the seat of honour of the head of state – a custom introduced by the grand masters – which was dismantled when Malta became an independent republic.

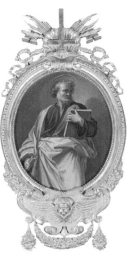

St Peter

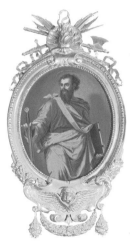

St Paul

**On the next page:
Mattia Preti,
*Shipwreck of St
Paul* in the conch**

**Opposite:
General view of
the Chancel**

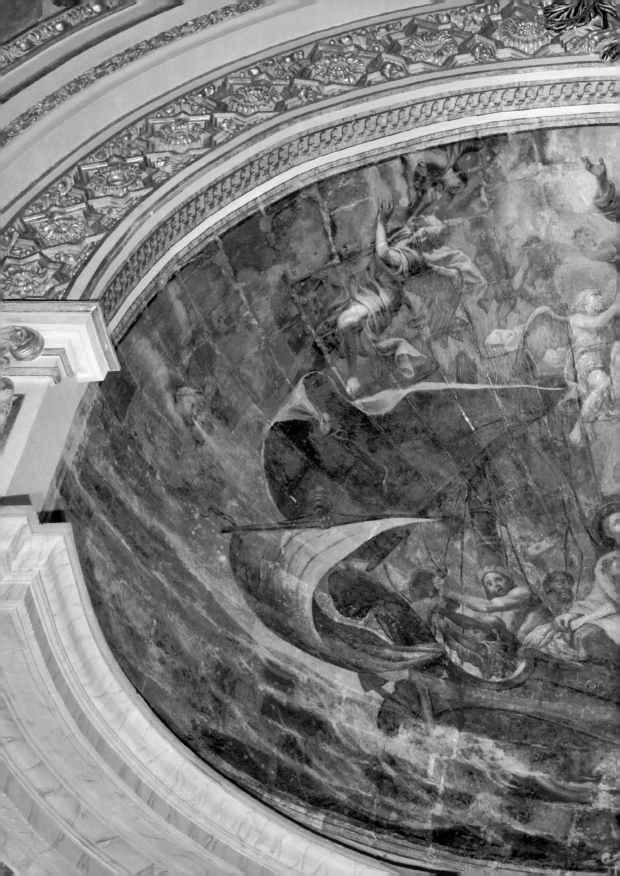

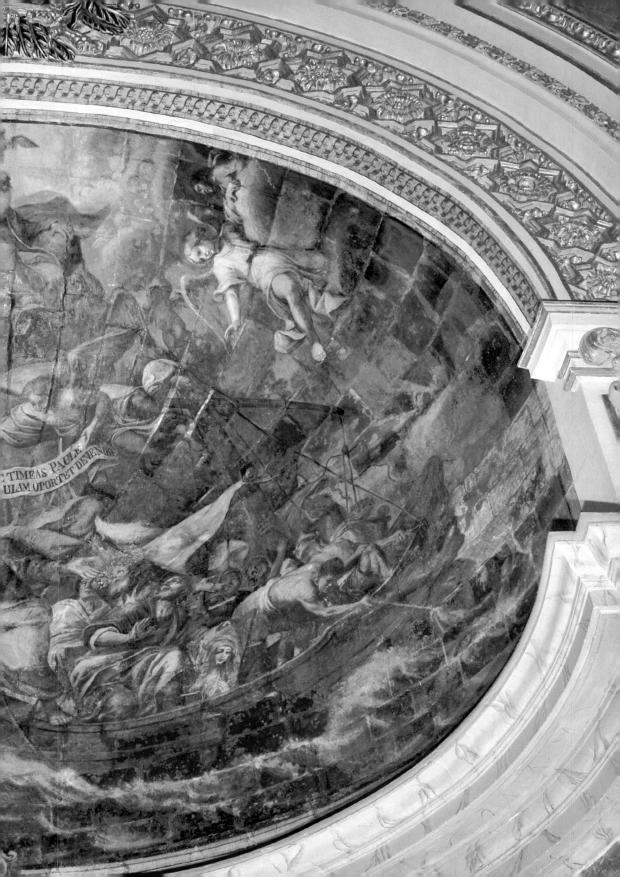

NE TIMEAS PAULE
ULAM UPORTET DENENIRE

THE CHOIR

Opposite:
Titular altarpiece,
Mattia Preti,
*Conversion of St
Paul*

When the plans for the decoration of the choir were taken in hand, Archbishop Alpheran left a bequest of 6,000 *scudi*, but he died before the project had begun. After long discussions, the chapter commissioned Stefano Ittar to produce a project to finish the choir nave. The artistically decorative altar is finely blended and has two pairs of large puttini at the ends of the upper part. The marble for the altar was brought from the ruins of Carthage. Similarly the four pilasters are covered with Carthaginian marble. The expenses of the extremely rich marble pedestal of the cross in the middle of the altar were paid by the Auxiliary Bishop Domenico Sceberras, titular bishop of Epiphania. Still higher up the coat of arms of the Spanish royal family stands gloriously in memory of Emperor Charles V who granted the Malta to the Order of St John in 1530. In the old cathedral it was also placed in the same place. The old wooden arms are now in the Cathedral Museum. The present arms in stone painted and gilt are those of the then reigning emperor, Ferdinand II.

As already stated, following the construction of the choir, a few years

The Choir

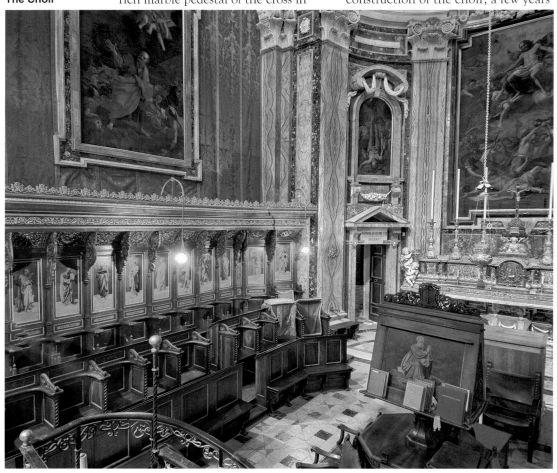

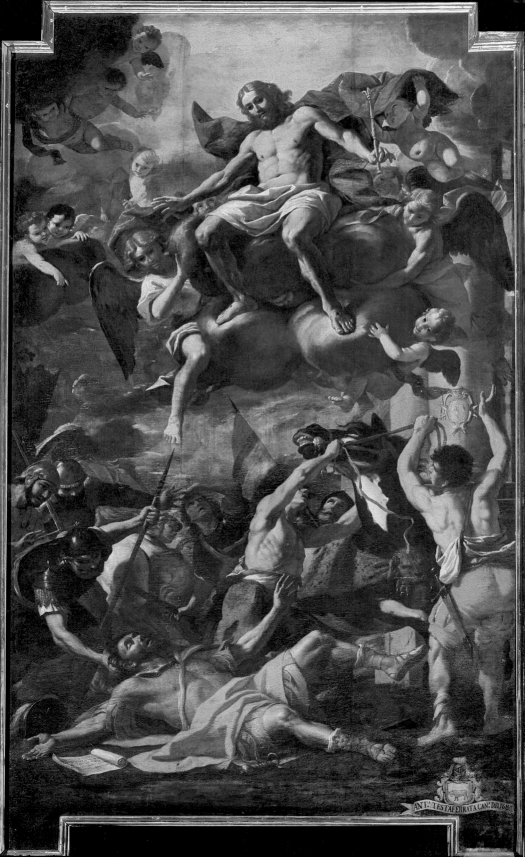

ANTᵒ TESTAFERRATA CANⁱ DD 1680

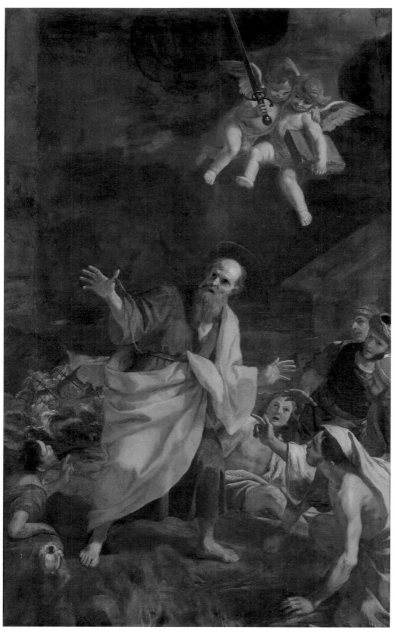

Mattia Preti, *The Miracle of the Viper*

on the limestone – an experiment used with success in St John's in Valletta. It belongs to the final period of the artist's brilliant career of and was largely carried out by *bottega* assistants under his direct supervision; he prepared the drawings and modellos and supervised their execution. The barque of the apostle is swelled up to fill most of the concave area and shows a feverish activity among the sailors. The cherubs from the cloudy heaven bring comfort to the apostle who becomes the focal point of the picture. The armorial shield of the Testaferrata family is carved and painted beneath the apse to commemorate the donor, Canon Antonio Testaferrrata.

The titular altarpiece of the *Conversion of St Paul on the Road to Damascus* above the altar relies for its effect on dynamic interlocking masses captured in the moment of agitated confusion provoked by Saul's sudden blindness. The other paintings in the choir are all by Mattia Preti.

The two Baroque frames between the pilasters depict the martyrdom of St Peter and of St Paul by Preti. *St Paul* reveals the work of the *bottega* as guided by the master himself who had prepared the original sketch. *St Peter* is a better work and shows a very good drawing,

before the great earthquake of 1693, Mattia Preti had been commissioned to decorate the new choir with a new altarpiece, the conch above it, and lateral paintings. The conch is a large mural of *The Shipwreck of St Paul* which is painted in oil directly

particularly in the supple body of the saint crucified head downwards.

Mattia Preti is clearly present in the two companion canvasses of the choir: the *Miracle of the Viper* and the *Healing of Publius' Father*. The latter painting is the better work and succeeds in recapturing something of the Venetian-tinged opulence of St John's ceiling. Probably this is the frail old master's last truly significant work. The good points of the *Miracle of the Viper* lie in the sustained drama of its rhetorical theatricality.

The choir stalls, with an old Gothic style background, are in part fifteenth-century work and were transferred from the old cathedral. The panels themselves, with inlaid carvings of the apostles and some doctors of the Church, were executed by Emanuele Decelis of Floriana in 1876 to the design of Friedrich Overbeck (1789-1869) of Rome. The original panels dating from 1481 may be seen in the Cathedral Museum. Other intarsia wood work is seen on the lectern of the choir. On its base, there are four music-playing angels while the slanting sides of the upper part represent *St Paul being taken to Heaven* from a design by Giuseppe Hyzler and *David playing his Harp*

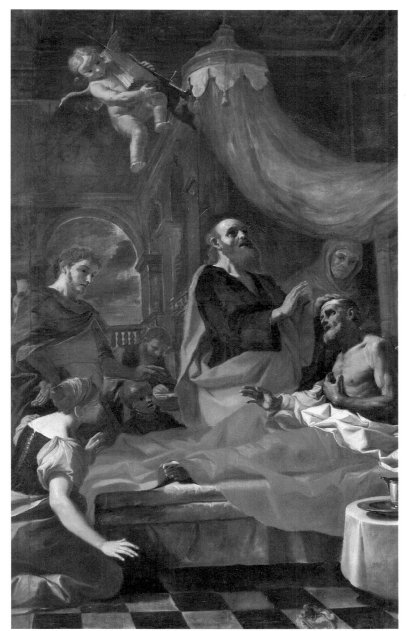

based on a detail from a painting by Overbeck.

The floor of the chancel was paved in marble after the tombs of five bishops had been removed. The central coat of arms in the floor is that of Bishop Gaetano Pace Forno.

Mattia Preti,
Healing of
Publius' Father

THE SOUTH TRANSEPT

Opposite:
Chapel of the Holy
Crucifix

To the left side of the high altar, there is the chapel similar dedicated to the Holy Crucifix, also called the *Calvario*. The inlaid marble floor has an excellent artistic design by Francesco Zahra made in February 1765. The marble work was carried out by Claudio Durante, who was the most artistically conspicuous member of a gifted family of marble workers from Senglea.

In May 1648 Bishop Balaguer y Camarasa donated to the old cathedral a carved wooden crucifix that he had commissioned from the Sicilian Franciscan Friar Innocenzo da Petralia Soprana. Frate Innocenzo was a competent and well-documented sculptor in the Spanish-Sicilian baroque tradition. He excelled in large crucifixes whose lifelike realism and extreme polychromatic verisimilitude creates an illusionistic effect. The crucifix was originally displayed in the Cagliares sacristy in front of the Garagona painting. In the new cathedral it was placed in this chapel flanking the choir. Here, the crucifix is accompanied by the carved, painted, and gilded wooden statues of Our Lady of Sorrows and St John. These are probably contemporaneous to the crucifix and seem to come from the same artistic milieu.

The crucifix which took the place of the Innocenzo da Petralia crucifix in the sacristy is artistically a more remarkable piece of work. This is a bronze *Cristo Vivo*

Copy of the icon of St Paul

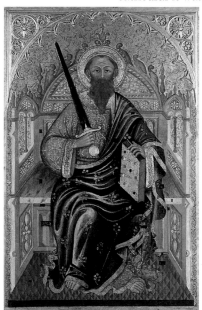

mounted on an ebonized cross with an INRI scroll and Adam's skull and it is attributed to the famous Alessandro Algardi (1598-1654).

Worthy of note in this chapel is the canvas of the *Deposition from the Cross*; which is difficult to place stylistically. It is a copy of a Mattia Preti work which lies in the Giuseppe de Vito collection in Milan.

On the left wall is a recent (1969) copy of the icon of *St Paul enthroned with a Sword in his Hand*; the original formed part of the main altarpiece in the old cathedral, – it is now exhibited in the Cathedral Museum. It was removed from its place in 1682 to make way for the large altarpiece by Mattia Preti. The icon was placed under the large canvas above a small altar. In 1782 the present altar was ready and the icon was transferred to its new place. The original icon, now replaced by the copy, was covered in silver which outlined the painting underneath; it is a gift to the chapter by Canon Melchior Napulon made in 1767. Two inscriptions give the name of the donor and the date of its manufacture by Michele Brandes of Rome. This chapel is also enclosed by a gate similar to that of the chapel of the Blessed Sacrament.

A sodality of Our Lady of Sorrows was founded in this chapel in 1743 by Bishop Alpheran. The Mdina cathedral crucifix was invoked in times of national calamity, such as droughts and plague epidemics. St George Preca frequently stopped for long hours to pray before this crucifix before the foundation of the *Società della Dottrina Cristiana*, M.U.S.E.U.M. He used to accompany the first members of the society who stood in meditation on the Holy Passion of the Lord in front of this crucifix.

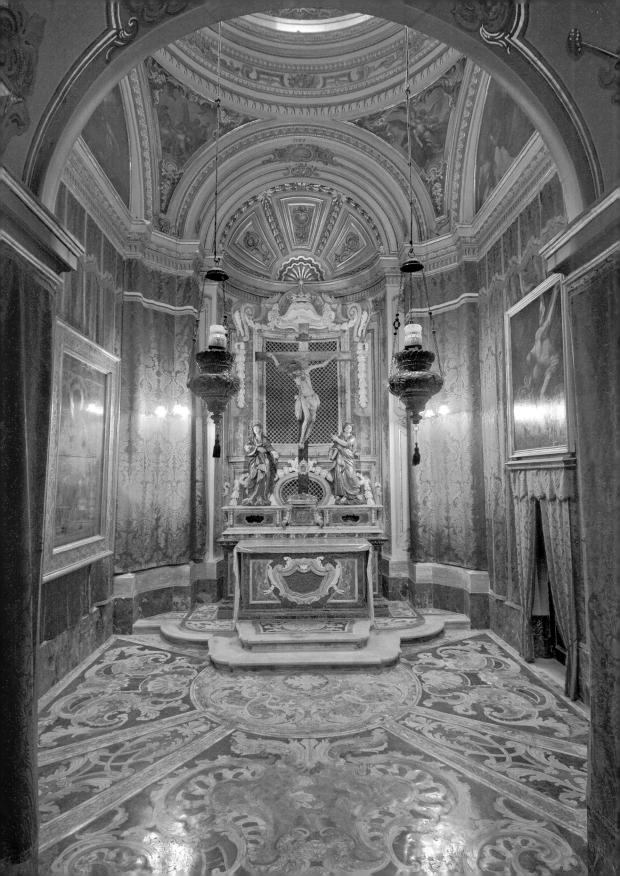

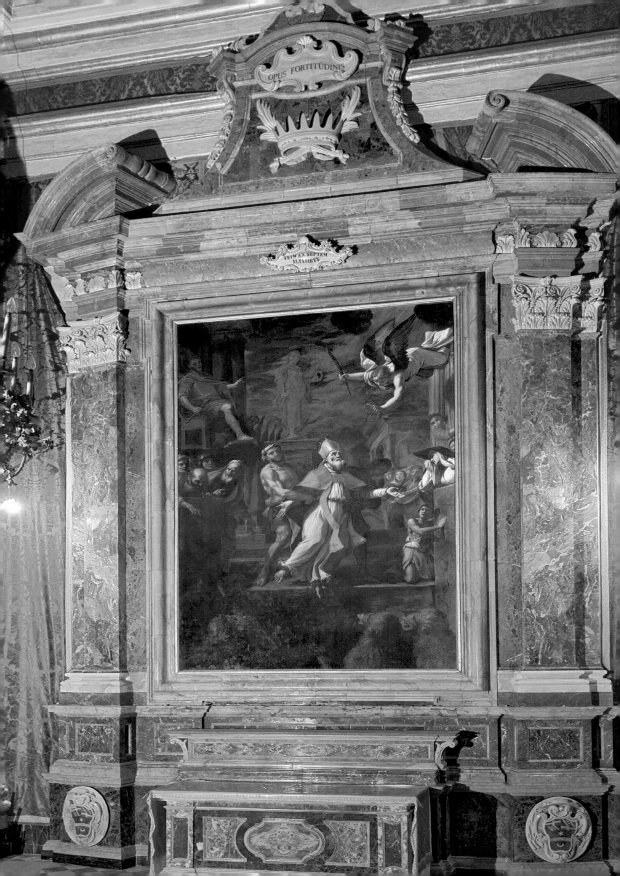

OPUS FORTITVDINIS

VNVM EX SEPTEM
ALTARIBVS

THE SOUTH TRANSEPT AND AISLE

The right-side transept aisle is dedicated to St Publius. The altarpiece, representing *The Martyrdom of St Publius*, is a stylistically and chromatically related painting which comes from the *bottega* of Preti and may, in fact, be his own work. It is an ambitious and crowded work of uneven quality, similar, in some way, to Preti's martyrdom scenes. The composition, based on a system of horizontals and diagonals, centres around the well-resolved figure of Publius in full pontifical robes, who heads a group of Christians being conducted to the arena. The artist intelligently manipulates pictorial skills and devices to overwhelm the spectator and make him share in the agony and glory of the saint.

The marble coats of arms flanking the altar are particularly well executed. On either side is the coat of arms of Bishop Gori Mancini surmounted by the blazon of Grand Master Zondadari who ruled during Gori Mancini's bishopric.

The next bay, with its door leading to Archbishop Square and to the Cathedral Museum, contains an elaborate monument to Bishop Carmelo Scicluna (1875-85). The door of this bay leading to Archbishop Square is embellished with bronze decorations in the form of wide-headed nails. Beneath the two statues in bronze of the Apostles Peter and Paul which complement the decorations, there are two medals containing the coat of arms of Bishop Balaguer. This door was very probably used in older times to separate the bishop's palace from the cathedral.

Two canvasses in the next two aisles come from the *bottega* of Mattia Preti. The altar piece of *St Cajetan*

is emblazoned with the armorial shield of the Bologna family who have their family burial vault in the crypt under the chapel. The impact of Preti on the altarpiece is watered down by other influences, although the Virgin and Child and the kneeling St Nicholas are borrowed from the master's hand. The two coats of arms painted on the picture can also be seen in marble on the outside flanks of the altar. One is that of the Mangion family; the other that of the Bologna family. The

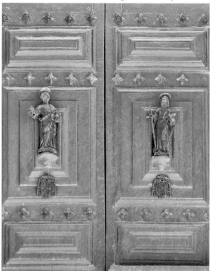

Monument of Bishop Carmelo Scicluna (1873-85)

Opposite: Altar of St Publius with an altarpiece by the *bottega* of Mattia Preti

Bronze statues of *St Peter* (left) and *St Paul* (right) on the main door

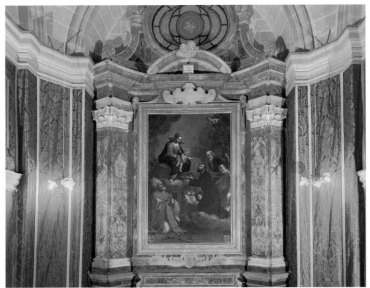

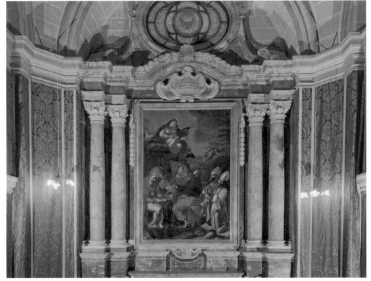

Altarpiece of St Luke (top) and St Cajetan (below)

Opposite: The altar of the Repose, constructed every year during Holy Week

from a weak composition. Luke sits down on a stool to paint a family portrait of the Virgin who appears with the Child in the top right-hand corner. The sainted bishops Trophimus and Aristarcus, companions of his Maltese adventure, and other saints either discuss Luke's gospel or point to the heavenly apparition.

During Lent, a magnificent baroque *Altar of Repose* with elaborate architectural features and an exquisite silver tabernacle as the centre piece is erected in this chapel to serves for the exposition of the Blessed Sacrament on Maundy Thursday and Good Friday. It was constructed in 1754 by the Maltese artist Francesco Zahra to the design of Pietro Paolo Troisi, who was master of the mint.

The earliest surviving episcopal memorial in the Mdina cathedral commemorates Bishop Tommaso Bosio (1538-39), formerly vice-chancellor of the Hospitaller Order of St John. His tomb was marked with a white marble ledger stone which is now embedded in the wall of the inner vestry close to the entrance of the monumental staircase of the chapter hall. Another episcopal ledger stone, albeit in a ruinous state, is that of Bishop Baldassare Cagliares, a prelate of Maltese nationality and *uditore* to Grand Master Alof de Wignacourt who was also a benefactor of the cathedral. Five fragments have been pieced together and cemented into the wall in the vestry.

monument commemorates Cardinal Fabrizio Sciberras Testaferrata (1756-1843), the only Maltese cardinal who was archbishop of Senigallia and apostolic nuncio to the Swiss Federation during the turbulent years of Pius VII.

The altarpiece of *St Luke* is the better work. It is a crowded *sacra conversazione* piece which suffers

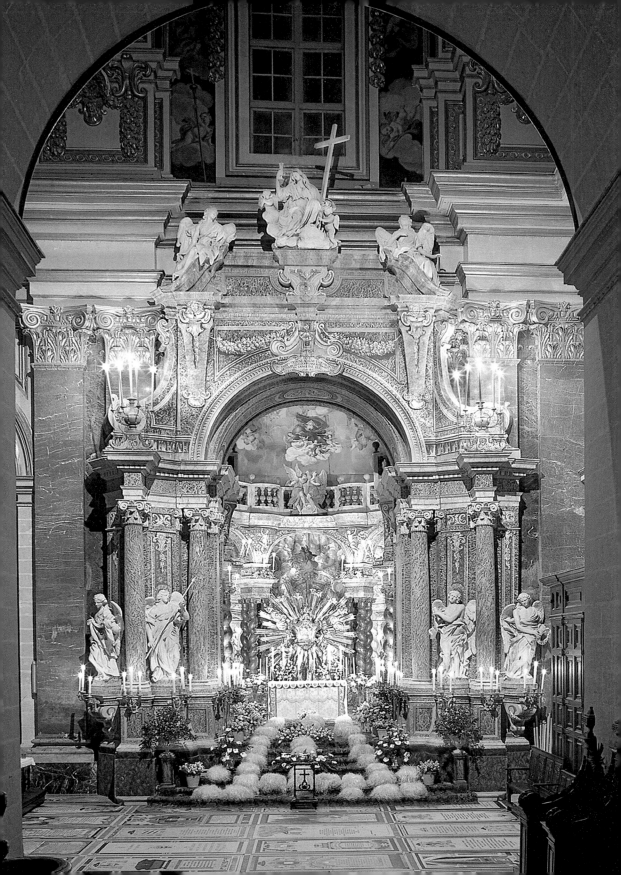

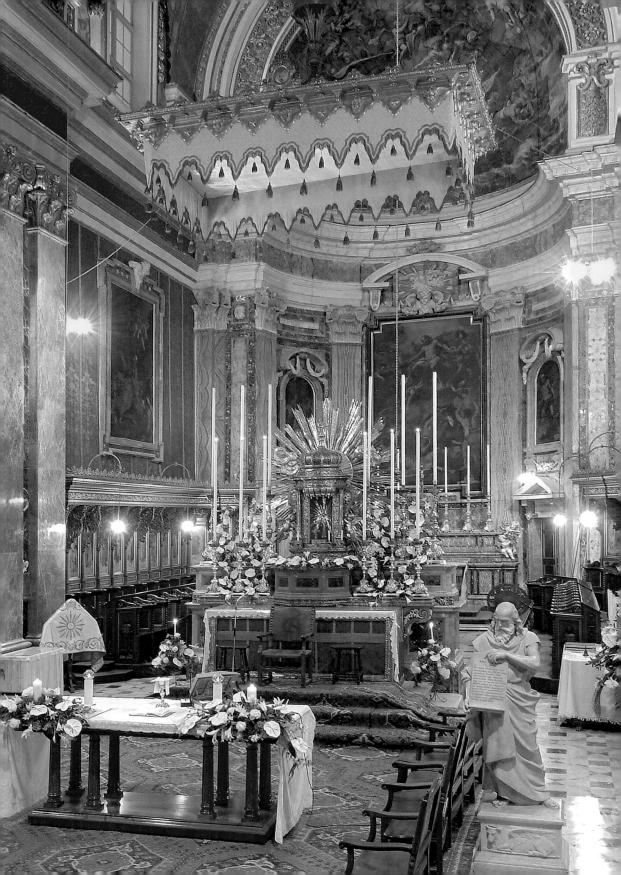

SILVER ARTIFACTS

A number of artifacts are exposed in the cathedral during solemn festivities and on different occasions.

One of the most significant *objets d'art* in precious metals that has survived from the old cathedral is a fifteenth-century processional cross, subsequently adapted to serve as an altar cross and which is still used to decorate the high altar on the principal liturgical feasts. Produced in gilded silver, it has curvaceous fleurs-de-lys patterned terminals and cast floral and acanthus-leaf motifs which bristle from it on all sides and create a richly decorative effect. This is further intensified by the chased and embossed foliated scrollwork which animates its two faces with an exquisitely refined delicacy. Its most remarkable element is, however, the cast angular figure of the dead Christ which with its agonized face, large inclined head, emphatically accentuated ribcage, and neatly defined planes of the torso and

stomach which is iconographically Romanesque. Technically, the cross reaches a very high standard. Artistically, it speaks a language of aristocratic refinement which the parcel gilding helps to diversify and enhance (1521 – probably Giuseppe Bonello).

A parcel-gilt monumental artifact is the *capsula* or tabernacle for the Holy Eucharist used on the above-mentioned *Altar of Repose* on Maundy Thursday. It consists of a central compartment, padded in fine silk with an arched flap-door hinged at the bottom. It has a silver-gilt symbolic pelican applied on the recto surrounded by an applied frame in a gilded acanthus leaf motif. The door is flanked by two side scroll pilasters with festoons of flowers and surrounded by a plane gilded cartouche from which descend festoons of flowers. On top of this section, there is a scroll pediment surrounded by a flame finial. A

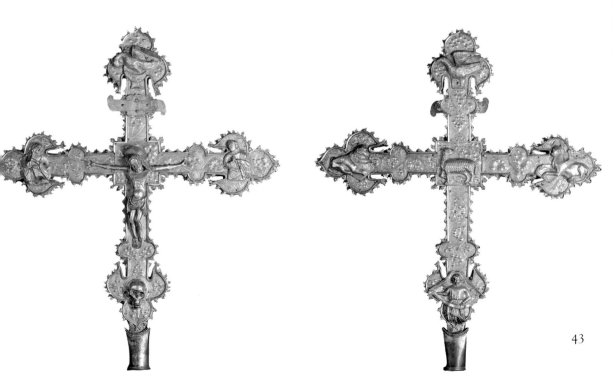

double cartouche bracket supports the upper structure. It has double shell chasing in the centre. It rests on a background of silver and gilded rays with a ring of single and double puttini heads applied on them. Two full figure puttini are also fixed on its sides. This whole artifact presents a breathtaking sight when it is exposed.

The large monstrance shrine or throne consists of a concave niche which revolves on a central pivot to screen the monstrance. Two columns with Corinthian capitals are flanked by two large scrolls with flower festoons supporting an overhead tasselled canopy surmounted by a domed closed oriental crown with a cross finial on a gadrooned and fluted stem. Two full-figured puttini are placed on the sides of the columns to create a better Baroque effect. The crown on top of the canopy has a red velvet material beneath the silver adornment. The base of the whole shrine consists of a pentagonal pedestal richly adorned with scrolls and acanthus leaves applied on a red velvet background. The whole artifact rests on six scroll feet. Antonio Famucelli was commissioned by the chapter to execute this artifact in 1718.

The large monstrance shrine used for the exposition of the Holy Sacrament

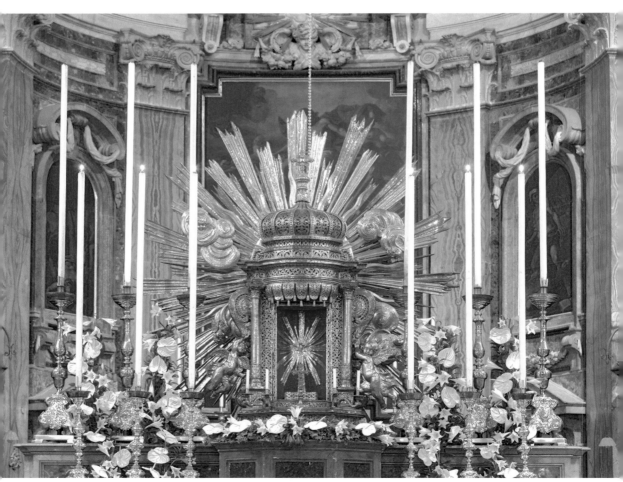

The silver statues and the processional cross

A magnificent set of 15 cast statues in parcel-gilt silver, representing the twelve apostles, St Paul, St John the Baptist, and Our Lady, stand on a square gilt brass pedestal on whose front there is an applied coat of arms. This set was definitely made by Antonio Arrighi, one of Rome's leading silversmiths, in 1741 and 1743. They were paid for by the prior of St Giles and the bailiff of St Stefano for the conventual church of the Order of St John.

These statues formed part of the booty stolen by Napoleon in 1798. The chapter, however, negotiated with the French authorities to exchange these statues with other silver artifacts which belonged to the cathedral. Full lists of the exchanged items are extant in the Cathedral Archives. The statues are displayed on the main altar of the cathedral on Christmas Day and on the two festivities of the conversion of St Paul in January and on the feast of the Sts Peter and Paul on 29 June, commonly known as *L-Imnarja*.

Another important parcel-gilt processional cross, consisting of two gilded sheets of silver on a wooden base, stands on a staff 202 cm tall. The terminals are cruciform and on the recto there is the effigies of Our Lady on the right and of St John on the left. On the top terminal, there is the effigy of Adam and on the bottom one that of a pelican, all in high relief. The crucifix in the centre of the recto is of Greek design and has a cross at the back fixed to the original cross. This crucifix is not contemporary in design with the original cross and may have been a late addition. On the verso on the four terminals are

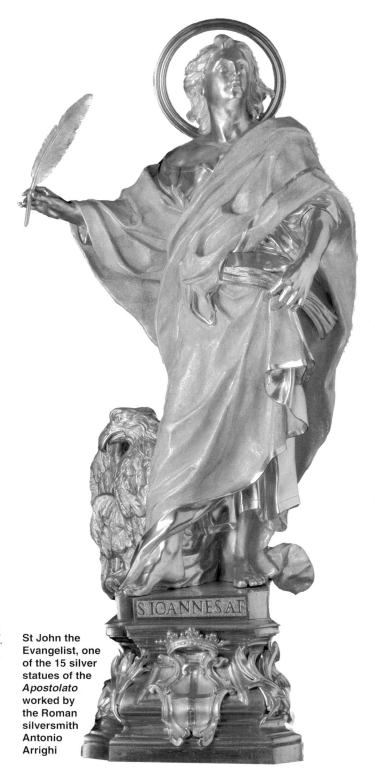

St John the Evangelist, one of the 15 silver statues of the *Apostolato* worked by the Roman silversmith Antonio Arrighi

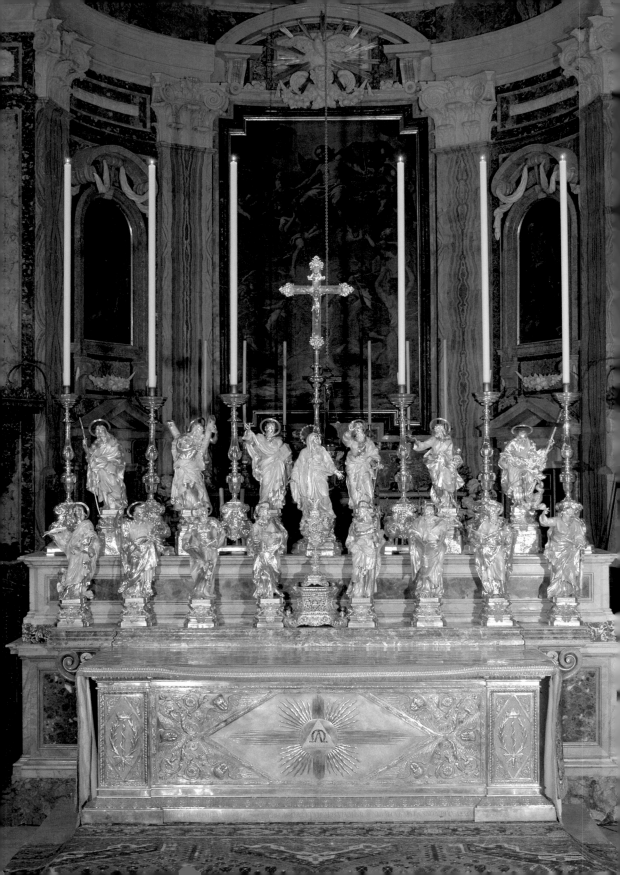

the symbols of the four evangelists with the effigy of St John the Baptist in the centre, all in high relief and contemporary with the figures on the recto. The two coats of arms at the base of the cross are a later addition to the original cross. The cross rests on a hexagonal base which reproduces a Gothic domed structure There are the effigies of Our Lady and five saints, including a mitred one. The staff, definitely a much later artifact, is chased on two planes with fluted medallions, alternating with another of flower motifs. This cross may have had four phases of production: the original cross, the Gothic base, the crucifix, and shields and the staff and knob.

A legend says that this cross was used by Peter De Buillion who led the First Crusade which entered Jerusalem. There must be some relation between this cross and the Order of St John since it bears the effigy of St John the Baptist. This cross must have reached the cathedral together with the 15 silver statues of the apostles that formed part of the exchange agreed upon between the French authorities and the bishop and the chapter in 1798.

Opposite:
The main altar
adorned with the
statues of the
Apostolato

Processional
crucifix

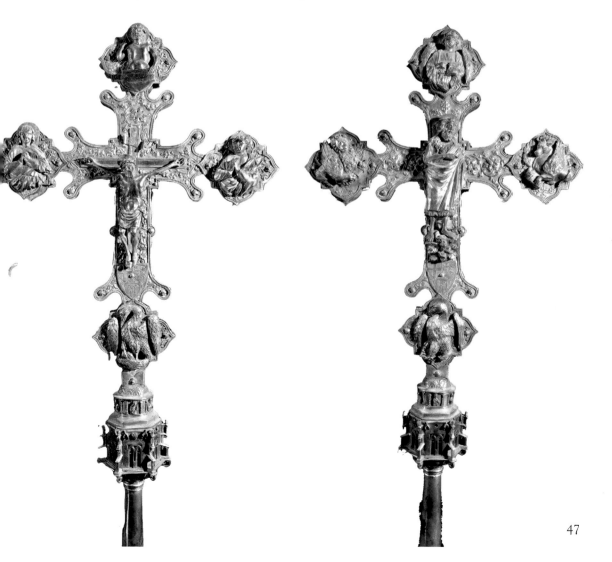

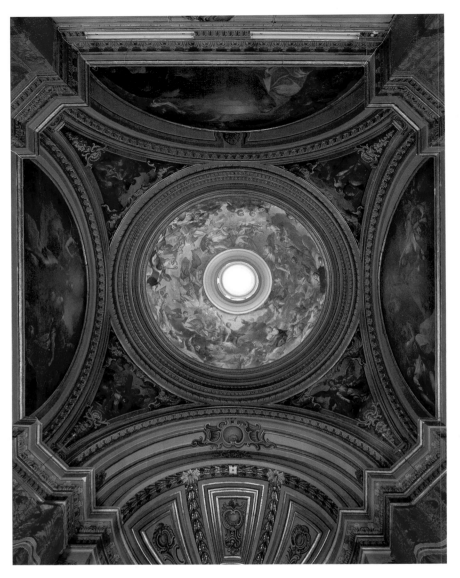

The dome of the Chapel of the Blessed Sacrament

FURTHER READING

Mario Buhagiar, *The Iconography of the Maltese Islands, 1400-1900*, Malta, 1988

Mario Buhagiar – Stanley Fiorini, *Mdina, The Cathedral City of Malta, À Reassessment of its History and a Critical Appreciation of its Architecture and Works of Art*, Photography by the Marquis Cassar de Sain, Malta, 1996.

Denis De Lucca, *Mdina: A History of its Urban Space and Architecture*, Malta, 1995

Conrad Thake and Quentin Hughes, *Malta: The Baroque Island*, Photography by Daniel Cilia, Malta, 2003

Other sources: ACM, Deliberationes, XIV, XVI, XVII
 ACM, Misc. 222.